A Picture Book of Birds

Copyright ©A Bee's Life Press
All Rights Reserved

Made in the USA
Columbia, SC
16 August 2021